# Etruscan Sculpture

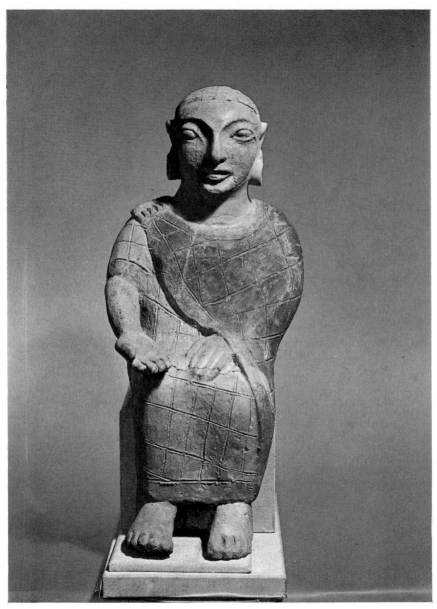

Figure of a seated woman. From Cerveteri. Height: 54·5 cm. (Terracotta D 219)

# Etruscan Sculpture

SYBILLE HAYNES

PUBLISHED BY
THE TRUSTEES OF THE BRITISH MUSEUM
LONDON
1971

SBN 7141 1234 8

PRINTED IN GREAT BRITAIN
AT THE UNIVERSITY PRESS, OXFORD
BY VIVIAN RIDLER,
PRINTER TO THE UNIVERSITY

# List of Plates

The map of Italy and Figures 1–3 were drawn by Miss M. O. Miller.

# Etruscan Sculpture

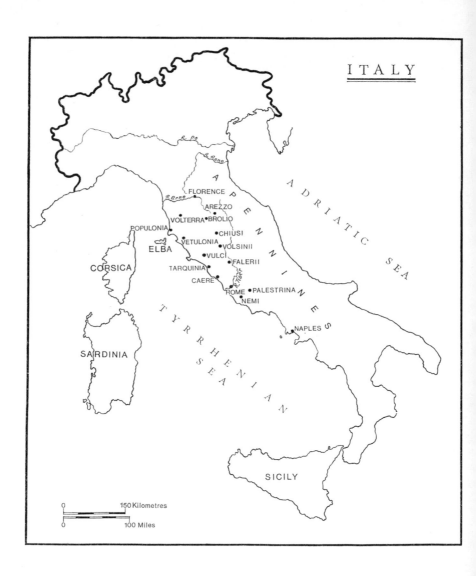

ITALY

FLORENCE
AREZZO
VOLTERRA ● BROLIO
POPULONIA ● CHIUSI
VETULONIA ● VOLSINII
ELBA ● VULCI
FALERII
CORSICA TARQUINIA ●
CAERE
ROME ● PALESTRINA
NEMI
NAPLES
SARDINIA

A D R I A T I C   S E A

T Y R R H E N I A N   S E A

A P E N N I N E S

R. Po
R. Reno
R. Arno
Tiber

SICILY

150 Kilometres
0
100 Miles
0

8

# Introduction

The rise of large-scale sculpture in Etruria is intimately connected with the funerary and religious beliefs of the Etruscan people. The earliest surviving Etruscan stone sculptures, which date from the second half of the seventh century B.C., were found, unfortunately badly damaged, in the 'Pietrera' grave-mound at Vetulonia in northern Etruria and are now preserved in the Archaeological Museum of Florence. Life-size figures of men and women, they originally stood in the architecturally treated central chamber of the tomb, which was furnished with stone bedsteads on which the bodies of the dead lay. This context clearly shows that the figures were either representations of the dead intended to ensure the survival of their likenesses, or images of divinities whose enduring presence was believed to protect the dead in the after-life.

A profound concern with the continuation of life in the beyond was to remain characteristic of Etruscan civilization until the first century B.C., and it is to this solicitude for the commemoration and protection of the dead that we owe a large proportion of the representations of human and divine beings in Etruscan art, as well as an extensive repertory of real and imaginary creatures endowed with powers to protect and to avert evil.

Another important stimulus for the carving or modelling of large-scale sculpture was provided by Etruscan religious ritual. Etruscan temples and shrines normally contained a cult-statue made of terracotta, or more rarely of stone or wood; and the temples were themselves usually decorated with terracotta figures in the round or in relief. Further, most sanctuaries were rich in votive offerings dedicated to the local gods by private individuals: large and small figures in bronze and terracotta, heads and other parts of the human body, animals of various kinds.

Secular sculpture of an honorific or commemorative character, which forms so large a proportion of later Greek and Roman art, is relatively rare in Etruscan; but we may assume that some, at least,

of the Etruscan portrait-statues of bronze and terracotta that have come down to us were originally set up in public places in honour of deserving citizens.

Unlike Greece, central Italy is comparatively poor in hard stone suitable for fine sculpture. The kinds most frequently employed in Etruscan sculpture are the local porous volcanic rocks (tufa and nenfro), sandstone, and limestone, none of which takes a high finish. Alabaster was worked in certain areas, notably at Volterra, but marble was only rarely used. The paucity of work in hard stone may not, however, be wholly due to the difficulty Etruscan artists had in finding suitable raw material; in part, at least, it may have been the result of a definite preference for modelling in soft media such as clay or wax, a branch of art in which they displayed exceptional talent.

# Etruscan Sculpture

The two seated women of terracotta with which we begin our survey are early and striking examples of this native skill in modelling clay. The statuettes on the frontispiece and on Pl. I were discovered in May 1865 in a chamber-tomb at Cerveteri, together with a seated male figure, now in the Palazzo dei Conservatori in Rome, and fragments of others. According to the excavators, the figures were found sitting on chairs carved from the living rock; and we may suppose these seats to have been similar in appearance to the high-backed thrones still extant in the Tomba degli Scudi e delle Sedie in the Banditaccia necropolis of Cerveteri (Fig. 1) which dates from about 600 B.C.

The female figures were acquired by the British Museum in 1873. They resemble each other closely: each sits with her right hand stretched out, palm up, to hold a bowl or other object now missing, while her left hand lies idly in her lap. Both have triangular faces with flat cheeks, low, smoothly rounded foreheads, wide almond eyes, prominent noses, and quizzical mouths. Old photographs show them with Victorian-looking buns of hair; but these were removed as modern restoration when the figures were cleaned in 1954. Both wear a tight short-sleeved dress and a boldly chequered cloak with a plain wide border on which traces of red paint are still preserved. Comparable tubular dresses of heavy material with a pattern of squares or lozenges occur on other figures of the later part of the seventh century, particularly on terracotta figurines decorating funerary urns from the region of Chiusi; it was perhaps a ritual garment. The seventh-century date suggested by their dress is confirmed by the women's jewellery, the large clasps resembling double combs which fasten their cloaks on the right shoulder, and their wide, cylindrical ear-rings. Actual clasps and ear-rings of identical form in gold and silver have been found in princely tombs of this date in south Etruria.

It has frequently been assumed that the statuettes are portraits of

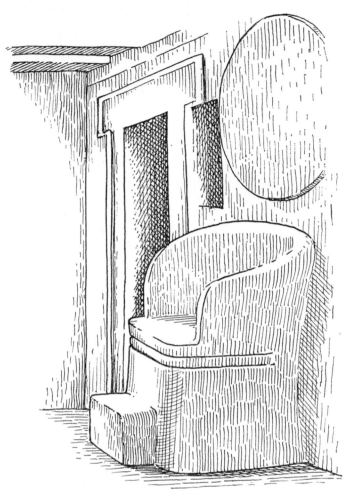

FIG. 1

the members of the family buried in the tomb. But the similarity of
their faces (which they share with the male figure in Rome) rules out
any idea of individual likeness. They may have been meant to 'stand
for' the dead persons, but portraiture in the modern sense is un-
known at this early period. Nevertheless, the statuettes are far from
being mere lay figures: they are full of vitality and convey a strong
sense of bodily volume. In this they exemplify a new conception of

the human body which Etruscan artists learnt in the course of the seventh century B.C. from bronze and ivory figures imported from the eastern Mediterranean, a region where sculpture in the round already had a long history. In the earliest phase of Etruscan art before it was subject to these 'orientalizing' influences, that is to say, in Etruscan art of the eighth and early seventh centuries B.C., the bodies of men and animals, as we can see from numerous small bronze figures, were treated as geometric abstractions of the natural forms: they lack substance and their limbs are wiry and unarticulated. But if our terracotta statuettes betray Eastern inspiration in their feeling for volume and organically rounded shapes, the cheerful energy of their faces and the disproportionate size of their heads and extremities are characteristically Etruscan traits. The stone figures from the 'Pietrera' tomb already show us Etruscan artists stressing those features which seem to them most important, especially the head, by an expressive exaggeration of scale or volume. The resulting distortion of the natural proportions of the human body is a recurrent phenomenon in Etruscan art.

The terracotta figures were found, and presumably made, at Caere-Cerveteri. Like neighbouring Tarquinia, Caere was a city where Etruscan civilization flourished with particular vigour from the eighth century B.C. onwards. The fortune of these south Etruscan cities was largely due to the exploitation of the mineral wealth of the Tolfa and Allumiere region and to the proximity of ports such as Pyrgy, Alsium, and Punicum, which provided an outlet for their products. Maritime trade and the prosperity to which it gave rise brought these cities into close commercial and cultural contact with the Levant and the Greek world, with the result that foreign luxury goods of every kind—gold, silver, bronze, ivory, pottery, and faience—appeared in central Italy and were copied widely and with varying success by native craftsmen. Furthermore, foreigners—mainly Greeks from Corinth at this period—are recorded as having set up workshops in Etruria, which played an important part in spreading the taste for Greek art.

Another city to achieve great prosperity as a result of foreign trade was Vulci, which lies to the north of Tarquinia and a little further inland. Vulci's wealth is reflected in the variety and splendour of the objects deposited in the countless tombs of the city's large cemeteries. One of the most important of the chamber-tombs—the so-called

'Isis Tomb' in the Polledrara necropolis—was opened in 1839. Amongst its rich contents, which were acquired by the British Museum in 1850, two pieces of sculpture take pride of place.

The first of these is the upper part of a woman, Pl. 1, composed of thin bronze sheets hammered into shape and riveted together, a technique known to the Greeks as *sphyrelaton*. As preserved, the figure ends below the waist in a hemispherical section embossed with a frieze of real and mythical animals—ibex, lion, sphinx, and winged feline. Rivet-holes in the lower end of this section show that it in turn was attached to something below it, but whether this was simply some kind of base, or whether the figure was completed by a skirt of which the hemisphere represents the upper part, we have no means of knowing. The woman's narrow waist is encircled by a broad belt decorated with a meander pattern, above which she is naked save for an elaborate choker of rhomboid beads round her neck. Her right forearm is missing, but she stretched it forward from the elbow, holding out a horned bird in the clenched hand. Unlike the rest of the figure, this hand and the bird are made of cast metal, and the bird was originally covered with gold foil, part of which is preserved. The woman lays her left arm across her chest, the hand holding the right breast. The head is disproportionally large; the level eyes (which may once have been incrusted with some coloured material), the short, thin-ridged nose and pinched lips, the massive jaws and heavy chin give the face an expression of prim austerity. The hair falls in a mass down the back, the diagonal markings of the individual tresses forming a herring-bone pattern. From behind each ear a separate tress, formed by a tube of metal, falls forward on the shoulder.

Whom does the figure represent? A nude female figure is a great rarity in the Etruscan art of this early period, but in Oriental art figures of naked women, richly adorned with jewellery and holding one or both breasts, are exceedingly frequent, being representations of the goddess of love, fertility, and death. Moreover, this Eastern divinity and her priestesses are sometimes associated with birds. There can be little doubt that our Etruscan bronze bust owes its inspiration to Oriental models of this kind and that she, too, represents a divinity. That her attendant bird is also a supernatural creature is proclaimed by its horns. Stylistically, the nearest parallel for the bust is provided by a cast bronze statuette of a woman found at

Brolio and now preserved in the Archaeological Museum of Florence (Fig. 2). The proportions of the upper part of this figure, her hair-style, her features, her choker and wide, patterned belt are strikingly similar. The Brolio statuette is generally dated to the first quarter of the sixth century and the date of our bust cannot be very different. The animals on the hemispherical section are copied from those painted on Corinthian pottery of about 650 to 625 B.C., but it would not be surprising to find a time-lag of some decades between the original and its provincial imitation.

FIG. 2

The second figure from the 'Isis Tomb' is a half-life-size statuette of a woman in gypsum, one of the best preserved of the surviving examples of archaic Etruscan sculpture, Pl. 2. She stands with her feet apart and firmly planted on a square base and stretches both arms forward from the elbow. The bowl she presumably supported on the open palm of her right hand is missing, as is also the offering she grasped in her clenched left. She wears a long belted dress and a cloak covering her shoulders and back and hanging down in two pointed panels in front of the body. The hem of the dress was decorated with an intricate chain of lotus-flowers rendered in paint, traces of which survive. Her head, which sits directly on the square shoulders, is big and cube-like, the forehead low, the eyes huge and staring with strongly arched brows, the nose heavy and triangular with deep furrows running down to the corners of the grimly smiling mouth. The hair forms an almost horizontal row of scalloped curls above the forehead and hangs down her back in nine plaited pigtails tied together at the level of the waist. From behind each ear two beaded tresses fall forward over the shoulders, reaching to the breasts.

In this figure we can recognize, for the first time, the strong

15

influence of Greek sculptural prototypes. Next to the naked male figure, the standing draped female figure was the favourite subject of Greek sculptors during the seventh and sixth centuries, and there can be little doubt that the Etruscan carver of our gypsum figure derived his main inspiration from a large-scale Greek votive statuette, probably the work of a Peloponnesian sculptor. Eastern influences are also discernible: the curious hair-style, for example, goes back to an Oriental fashion much imitated in seventh-century Etruria, and the pose of the arms is typical of Hittite and Syrian figures of the preceding centuries. Yet despite these heterogeneous elements, the figure not only possesses a remarkable formal unity and a monumentality which belies its actual size, but is also typically Etruscan. Indeed, we can go further and say that the treatment of its features is typically Vulcian. An indication of the date of the sculpture is given by the lotus-pattern on the dress, a pattern frequently found on Corinthian and Attic painted pottery of the first decades of the sixth century. It may have been carved about 570 B.C.

During the seventh century Chiusi, the most important city of north-eastern Etruria, also began to develop an individual style of sculpture. Since the burial custom most widely practised in this prosperous agricultural region was cremation, ash-urns form the bulk of the early funerary sculpture found there. A particularly interesting class of these, comprising examples in both terracotta and bronze, is known as 'Canopic' urns, because they bear a superficial resemblance to the Canopic jars of Egypt. The earliest examples of this type are purely functional in shape; but later urns assume increasingly anthropomorphic features. In some cases masks of bronze or clay were tied to the ovoid vessels in an attempt to impart a human character to them. Sometimes the lids of the urns were modelled in the shape of fully rounded human heads. Occasionally the handles on either side of the vase were given the form of arms, and the urns themselves were often placed on miniature chairs, fashioned in imitation of real chairs. Unfortunately, few of these 'Canopic' urns have been preserved together with the objects originally associated with them in the tombs from which they were recovered; and it has therefore not been possible so far to work out a satisfactory chronological sequence for their stylistic development.

The problems involved in dating them on stylistic and formal grounds alone are clearly illustrated by the urn, Pl. 3, which com-

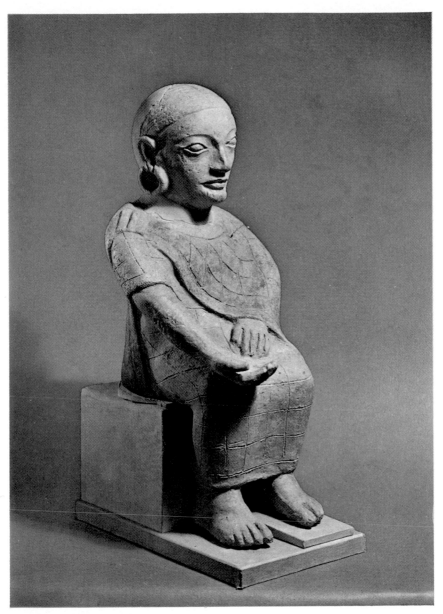

PLATE I. Figure of a seated woman. From Cerveteri. Height: 54·5 cm.
(Terracotta D 220)

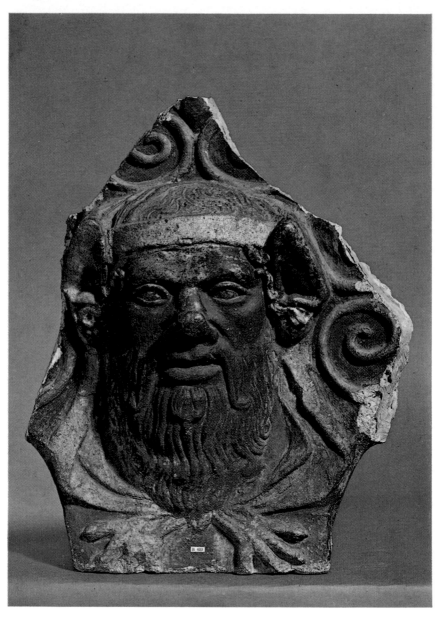

PLATE II. Head of a satyr. From Cerveteri. Height: 40·1 cm.
(Terracotta B 623)

bines both 'early' and 'later' features. Made of reddish-brown clay, the ovoid vessel shows an interesting step towards anthropomorphization: it has been given the semblance of a human thorax by marking the sternum furrow down the centre of the front. Nevertheless, the handles are still simple straps, lacking any suggestion of organic form. The lid is shaped in the round like a human head, but the face is curiously flat and obviously derived from the stylized masks tied to earlier urns. Its crudely modelled features are perforated by a number of holes which may have served to hold a layer of metal foil in place. A row of holes round the bottom of the neck perhaps secured a metal necklace in position. Roughly incised parallel lines indicate the hair on top of the flat skull. The urn stands on a clay chair of typically Etruscan form, the lower part shaped as a truncated cone, the upper part flaring outwards at the back and the sides cut away in curves in front. Closely comparable in type is a large throne of hammered bronze sheet found in the so-called Barberini Tomb in Palestrina, the contents of which date from the middle of the seventh century. Our urn may have been made at the end of the century.

The sixth century saw the ties between Greece and Etruria growing closer and more complex. Attica and Ionia now begin to provide the main source of inspiration for Etruscan artists, and Peloponnesian influence declines. Fine painted pottery from Athens was imported into Etruria in increasing quantities, while Ionian taste was spread by Greek traders and immigrants from the west coast of Asia Minor. Some of these started potters' workshops at Caere in south Etruria. The painted figure decoration of Caeretan pottery did much to popularize the ideal type of Ionian beauty characterized by receding foreheads and chins, domed skulls, and long, slanting eyes.

By the beginning of the sixth century Chiusine sculptors are starting to carve their local limestone. During the first half of the century their repertory is still very restricted, consisting in the main of guardian animals for tombs, especially sphinxes and lions, and of curious female busts on drum-like supports (Fig. 3), also funerary in character, having served either as tomb-guardians or tomb-markers. About 540 B.C., however, wealthy Chiusine families began to commission cinerary urns in the form of life-size human figures in stone, hollowed out to receive the ashes of their dead. The idea of placing

the incinerated remains in an anthropomorphic container goes back, of course, to the local use of 'Canopic' urns, but the figure types and the style are inspired by Greek models.

The earliest of these figures is that of a standing man, Pl. 4, which was found at Chianciano, near Chiusi. The body is carved in one piece and hollowed out, the separately-carved head serving as a stopper. The man wears a plain long robe and a mantle draped over his left shoulder. His hands, which he holds flat against his chest and abdomen, are virtually carved in relief. The lean, long-nosed face has huge visionary eyes set level under the arched brows. The lips of the taut mouth are shaven, but the prominent chin is covered by a smooth beard which reaches to the ears. The hair is parted in the centre above the high forehead and falls in a solid mass to just above the shoulders. Traces of red and black paint have survived on hair, flesh, and drapery.

In its pillar-like compactness the figure is reminiscent of the female busts on stone drums to which we have already referred, but the striking grandeur and austerity of the face is closely paralleled in Attic vase-painting of the third quarter of the sixth century, imported examples of which may have provided the model for the Etruscan sculptor. The dress, on the other hand, is Ionian, a fashion pre-valent in both Greece and Etruria

FIG. 3

in the later sixth century B.C. to which our figure must be assigned.

The Chianciano urn is unique in representing the dead in a standing position; all the other Chiusine stone ash-urns that have come down to us are in the form of seated figures. The earliest examples of

18

this seated type may have been modelled on East Greek figures of seated votaries such as the famous marble statues from Didyma, near Miletus, now in the British Museum.

The draped male figure sitting in an armchair, Pl. 5, was carved in four separate pieces: the hollow lower part of the chair with the man's legs, his solid torso and head, and the two forearms, now missing, which were originally dowelled into sockets at the elbows. The man wears shoes and a long, tightly fitting chiton. His big, almost neckless head has a strongly receding forehead and slanting almond eyes. Chin and jaws are covered by a beard on which traces of black paint are still preserved. The hair, also originally painted black, is brushed straight back in thick, rope-like tresses, an unbecoming hair-style which occurs in Etruscan sculptures of the seventh and early sixth centuries and seems to be a local fashion. The armchair is of the typically Etruscan form we have already met in the rock-carved examples of the Tomba degli Scudi e delle Sedie (Fig. 1).

In this figure, too, Ionian influence is manifest: not only, as we have already noted, in the type of the seated figure, but in the heavy, rounded forms of the body and the fleshiness of the face. Being very summarily executed, it is a difficult piece to date at all closely, but it was probably carved during the later part of the sixth century, when the Ionian fashion was at its height.

Large anthropomorphic ash-containers of the type we have just been considering are comparatively rare; far more common in sixth- and fifth-century Chiusi were smaller funerary monuments, including cippi (tomb-markers), ash-chests, and sarcophagi carved from the local limestone and decorated with delicate low relief. The subjects of these sculptures are among those familiar to us from Etruscan vase-paintings and frescoes in the subterranean tombs of Chiusi itself and, above all, of Tarquinia: the laying-out of the deceased, banquets and games, dances, and other scenes of daily life. Such representations can teach us a great deal about the habits of the Etruscans, their dress, their furniture, their utensils, and their pets and the animals they domesticated or hunted.

Pl. 6 illustrates the reliefs on the four sides of the lower part of a funerary cippus from Chiusi. On one side, Pl. 6a, we see the dead woman laid out on a bed, her body wrapped in a cloak, her head covered with a cap and supported on pillows; a long sheet covers the

mattress and hangs down at either end of the bedstead, which has elaborately turned legs. Two richly dressed women wave branches over the body, while a third proffers a cup, presumably a libation. Two youths at the foot of the bed converse with emphatic gestures. The next two sides, Pl. 6*b* and *c*, represent banqueting scenes. The young banqueters with wreaths on their heads and mantles covering their legs recline on couches in pairs, attended by boys. One boy plays a double-pipe, another has stopped playing to hand his master a fruit; two hold garlands. A pair of pet geese and a dog scavenge for crumbs under the couches, and a wide-necked amphora stands on the floor.

The subject of the fourth side, Pl. 6*d*, is the return from the chase: five young huntsmen accompanied by their dogs move in file to the right, talking animatedly. All but the leader are armed with wooden hunting-crooks, and the hindermost carries their meagre bag—a hare—slung from his. Such banqueting and hunting scenes may refer not only to the pleasures enjoyed by the deceased in this world, but to their continuation in the after-life.

A certain monotony makes itself felt in the facial types and in the arrangement of the drapery, a symptom of mass-production; but the artist manages, nevertheless, to convey an impression of lively movement by the rhythmical disposition of the figures and their expressive gestures. The receding profiles are a last echo of the Ionian ideal which dominated Etruscan art for many decades; but the treatment of the women's clothes, particularly the way in which the folds of their skirts are stacked in pleated bundles, recalls Attic sculpture and vase-paintings of the end of the sixth century. We may therefore assume that our cippus was carved about 480 B.C.

Last in our survey of the funerary stone sculpture from the productive school of Chiusi is an ash-urn carved in the form of a house, Pl. 7. The lower part is a plain, oblong box, but the lid is shaped as a ridge-roof, on which the sculptor has indicated in a simplified way the flat tiles, the rows of cover-tiles joining them, and the decorative end-tiles normally found above the eaves of Etruscan houses and temples. Three small holes in the front gable of the urn show that ornaments of some kind were originally attached to it, presumably small bronze plaques simulating the terracotta revetments which covered the wooden beam-ends on actual buildings. The wide projection of the eaves gives the urn a top-heavy look, reminding us of

the 'heavy-headed' Tuscan temples of which Vitruvius, the Roman writer on architecture, speaks. In front of the urn is seated a stern-faced female figure with outspread wings. She wears a long dress and heavy mantle and her tightly waved hair is crowned by a diadem. Her clenched hands rest on her lap; both once held objects now missing, in all probability bronze torches. In Etruscan art torches are the usual attributes of demons concerned with death, the tomb, and the passage of the soul into the beyond. Demonic, too, are the two panthers crouching on the ridge of the roof and baring their teeth, as if to guard the ashes. They are descendants of the ferocious animals the Etruscans used to place on watch in their cemeteries in archaic times.

It is difficult to date the urn closely. The artists of Chiusi, as we have already noted, were conservative and tended to go on repeating motifs many decades after they had fallen out of fashion in the more advanced coastal towns of Etruria. The serious expression of the winged demon, her formalized hair-style, and the treatment of the folds of her sleeved chiton and mantle are all features inspired by Greek models of the fifth century; but the tasselled ribbon hanging over her right shoulder is a detail peculiar to Etruscan feminine fashion, in which it occurs from the later fifth to the end of the fourth century. The urn may well have been carved after 400 B.C.

Meanwhile stone was not the only medium in which Etruscan sculptors had by now learnt to express themselves freely. By the end of the sixth century they had also mastered the complex difficulties of making large hollow-cast statuettes of bronze, and the more primitive technique of hammered sheet-bronze which we have already met in the bust from the 'Isis Tomb' (pp. 13 f.) had been entirely superseded. Indeed, so successful were the Etruscans as bronze-casters and metalworkers that the fame of their work spread all over the Greek world in the fifth century B.C. (Cf. S. Haynes. *Etruscan Bronze Utensils*. British Museum, 1965, p. 9.)

The excellence of their achievements and the difficulties they encountered in hollow-casting are simultaneously illustrated by the votive statuette of a slim standing girl said to have been found in the neighbourhood of Naples, Pl. 8. Owing to some fault in the casting process, cracks have developed round the waist and down the right side of the figure, through which the clay core is still visible. Despite

these flaws, the statuette is a delightful piece of sculpture, strongly yet sensitively modelled and full of life.

The girl is dressed in a clinging chiton, the details of which—folds, flowered embroidery, and buttons—are delicately incised; and on her feet she wears *calcei repandi*, soft leather boots with upturned points, characteristic of Etruscan ladies. Her long wavy hair is crowned by a diadem. Her forearms (separately cast and attached by rivets at the elbows) are raised in front of her, the elegant, long-fingered hands outstretched in a gesture of offering or prayer; in her right hand she once held a votive gift, perhaps a flower. Coloured inlays in the eyes would originally have heightened the expression of the pleasing, oval face. A close parallel for the structure of the face is provided by a terracotta antefix found at Rome and dating from the period of Etruscan rule and by other antefixes reproducing the same general type which have been found at Cerveteri. These comparisons suggest that the bronze statuette was made in a southern Etruscan workshop in the late sixth century B.C.

Slightly later in date is the bronze head of a young man illustrated on Pl. 9. Broken at the base of the neck, it may have come from a large statuette of a naked youth or *kouros*, a sculptural type invented by Greek artists (cf. p. 16), but popular in Etruria, too. The head is damaged at the back, and the remains of the core, stained to a rust colour by its iron content, are again visible. The youth's hair-style is based on a Greek fashion of the late archaic period: the long hair at the back of the head is twisted round a smooth cord or fillet to form a roll at the nape, while the shorter hair at the front frames the forehead in a series of meticulously rendered wavy strands which end in snail-curls. Apart from the full-lipped mouth, the face is treated with a certain harshness. The flat, unmodulated cheeks, the thin, evenly arched ridges of the brows, the crisply outlined almond eyes, and the summarily indicated ears give the head a remote and abstract quality, unlike anything found in contemporary Greek art: the Etruscan artist's main aim seems to have been the creation of an expressive surface-pattern. A number of small bronze figures whose faces are closely related to that of this head, have been found at Vulci, a city which seems to have had a flourishing bronze industry. It is possible, therefore, that the statuette to which our head belonged was a Vulcian work.

From the beginning of the fifth century onwards the Etruscans

suffered a series of naval and military defeats at the hands of their neighbours—Greeks, Samnites, marauding Gallic tribes, and, above all, the rising Roman republic—with a consequent progressive reduction of the territory under Etruscan control. The resulting decline in political power, industry, commerce, and overseas trade led to the severing of old-established ties, and this in turn appears to have led to a growing provincialism in art and a failure of creativity. The vigorous sculpture of the archaic age now gives way for over a century to works which echo and elaborate motifs of the late archaic and classical phases of Greek art. Deprived of fresh stimuli, the sculpture of the later fifth and fourth centuries conspicuously lacks the striking originality characteristic of earlier Etruscan adaptations of foreign prototypes, though its technical quality remains high. It is only in the Hellenistic period that a new wave of inspiration from south Italy, Greece, and Asia Minor revives the languishing arts of Central Italy and leads to a last burst of creative vigour.

A good specimen of the cool, classicizing work of this 'stagnant' phase of Etruscan art is provided by the life-size bronze head of a young man found in 1771 on an island in Lake Bolsena, Pl. 10. The head was long regarded as an extensively restored work of little interest, and it was only after the recent removal of the grotesquely inappropriate bust on which it had been mounted in the eighteenth century that its true worth became apparent. It can now be seen as one of the very few surviving examples of large-scale Etruscan bronze sculpture and an eloquent witness to the continuing excellence of Etruscan craftsmanship and its close dependence on earlier Greek models. Although the head must have been made about 350 B.C., the type harks back to the statues of young athletes created by the Peloponnesian sculptor Polycleitus a century earlier. Unmistakably Etruscan is the contrast between the shell-like hardness of the face and the elaborately patterned thick mass of hair, arranged in formalized grooved spirals on the temples. A finely hatched stubble covers the jaws and upper lip, a fashion unknown in classical Greece, but typical of Etruria. The find-spot of the head suggests that the figure to which it belonged may have stood in the ancient city of Volsinii on the north-eastern shore of Lake Bolsena. The Romans are said to have carried off as many as 2,000 bronze statues from Volsinii after sacking it in 265 B.C.

23

As we have already noted when looking at the house-shaped ash-urn from Chiusi (Pl. 7), Etruscan architects were in the habit of decorating the eaves of their roofs with ornamental end-tiles. First found in Greek temple architecture of the seventh century B.C., terracotta antefixes were particularly popular in Etruria where they continue until the first century B.C. The fragmentary terracotta antefix illustrated on Pl. II once adorned the roof of a fourth-century Etruscan temple at Caere-Cerveteri, where it was found together with numerous similar pieces. Made in a mould, it represents a satyr's head modelled in high relief and framed by a (now damaged) shell-shaped member decorated with a floral scroll. Satyrs, the mythical followers of the wine-god Dionysus, and their female companions, the maenads, are a favourite subject of Etruscan ante-fixes from the archaic period onwards. In early examples, where the evil-averting function outweighs the decorative, the bestial nature of the satyr is strongly emphasized, but in the classical period it is minimized. Here the lion-skin knotted on his chest hints at the satyr's wild outdoor life, and his ears are still equine; but the power-fully modelled, bearded face is thoroughly humanized, and the bulbous nose, slack skin, dropping lip, and dull eyes perhaps point to an all-too-human weakness for Dionysus' gift. Extensive remains of red, brown, and black paint on the antefix give a good idea of the vivid and colourful effect Etruscan temples must originally have produced.

Carved from the volcanic stone known as nenfro, the sarcophagus lid illustrated on Pl. 11 has vestigial gables at either end, survivals from the fully roof-shaped lids found on earlier sarcophagi and house-urns (Pl. 7). On the lid an elderly woman is carved in high relief, her pose an uneasy compromise between standing and lying: for while her weight appears to be taken by her right leg, her head rests on a flat tasselled pillow. She wears a chiton, a cloak, and, knotted on her right shoulder, a fawn-skin, and her hair is neatly confined by a ribbon and crowned with a thick wreath. Her ostenta-tious jewellery comprises a torque, a necklace with five round pen-dants or *bullae*, bracelets in the shape of serpents, and hoop ear-rings with disc pendants. In her left hand she holds a *thyrsus*, the ivy-tipped fennel-stalk carried by maenads, in her right a *cantharos* or wine-cup, towards which a lying or crouching fawn—again the pose is ambiguous—appears to raise its muzzle. Thyrsus, cantharos,

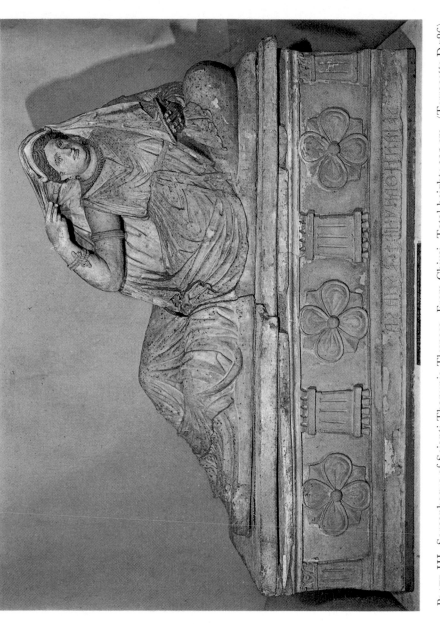

PLATE III. Sarcophagus of Seianti Thanunia Tlesnasa. From Chiusi. Total height: 122 cm. (Terracotta D 786)

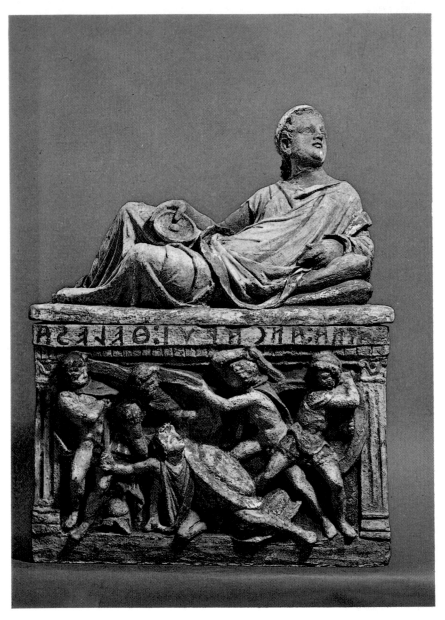

PLATE IV. Cinerary urn. From Chiusi. Height: 74·8 cm.
(Terracotta D 795)

fawn, and fawnskin, these are all attributes of Dionysus and indicate that the dead woman had been initiated into the Dionysiac mysteries which promised a blissful life in the next world. Despite some awkwardness in the composition of the figures, the high quality of the carving makes this sarcophagus one of the finest examples of its type. The unusual dignity of the matron's sombre features and such realistic details as her sunken eyes and cheeks suggest that the sculptor was trying to achieve an individual likeness.

The dress and jewellery point to a date about 250 B.C., in view of which the alleged provenance of the lid from the Tomba del Triclinio at Tarquinia seems questionable. This famous tomb, the walls of which were decorated with lively frescoes of banqueting scenes, dates from about 470 B.C., and though it might have remained in use for several generations, a span of more than two centuries is unlikely. It is, moreover, significant that there is no mention of the discovery of a sarcophagus in the first report on the opening of the tomb in 1830.

The bronze head shown on Pl. 12, once part of a life-size statue was acquired for Richard Payne Knight in Rome in 1785. It is the head of a young man wearing a close-fitting leather cap with narrow straps passing in front of and behind the ears and tied under the chin. This cap has often been taken for an *apex* or *tutulus*, the ritual headgear worn by Roman priests. But it lacks the characteristic spike on the crown of the *apex* and differs from all known representations of priestly caps in that it covers the hair completely, only allowing a few short wisps to escape. It is, in fact, an athlete's cap, closely resembling those worn by pancratiasts and other athletes on Greek red-figure vases; and the head probably comes from a statue erected to commemorate a victor in some athletic contest, for the vigorously modelled, fleshy features, bulging forehead, aquiline nose, and sensuous lips suggest a portrait, the realism of which would have been enhanced when the eyes still retained their inlay of coloured stone or glass and the lips their plating of colour. The asymmetry of the face and the slight twist to the right imply that it was originally meant to be seen in three-quarter view from the right. The head probably dates from the second half of the third century B.C.

A large proportion of the votive gifts found in Etruscan sanctuaries consist of mould-made terracotta heads dedicated to the local divinity by individual worshippers. This substitution of a part of the

figure for the whole reminds us again of the age-old tendency of Etruscan artists to over-emphasize salient features of the human body at the expense of a balanced totality. The process is frequently carried to the extent of reducing even the head to a front or profile view only, a development which may have been favoured by the fact that such half-heads can be produced in a single mould. These heads are either completely flat at the back and perhaps intended to be hung on a wall, or they are finished off in a roughly modelled, shallow curve, just deep enough to enable them to stand on a shelf. Curiously insubstantial in effect, they are, moreover, often poor in quality and dully repetitive, the same moulds being used over a long period. The fact that the heads are mould-made warns us against regarding them as portraits in the modern sense; but the modelling-tool might sometimes be used to give a head individual touches before firing.

Pl. 13 shows the half-head of a girl to the right. Though her lips and chin are slightly damaged, the outline of the youthful profile survives intact. Her hair is dressed in an attractive and unusual fashion. Over the forehead it is parted in the centre and falls in long corkscrew curls over the cheek. Behind it is brushed up from the nape and plaited into a long braid which is wound round the back of the head, so as to form a flattened crown. The girl wears an ear-ring in the shape of a spirally twisted hoop widening at one end into a lion's head.

Where our half-head was found is not recorded, but a series of closely related terracotta heads (now in the Museo Gregoriano Etrusco of the Vatican) were found at Cerveteri, presumably in the votive deposit of a temple; so it is likely that ours, too, is a Caeretan work. Heads of this type used to be dated to the second or first century B.C., but a recent study has convincingly shown that they were made in the early Hellenistic period. We meet the same very characteristic hair-style, for example, on the rapidly sketched profile head of a young woman on an Etruscan red-figure *crater* in Berlin, which dates from the early third century B.C.; moreover, hoop ear-rings ending in lion's heads, which are worn by some of the Vatican heads as well as by the girl in the British Museum, seem to have been particularly in vogue in the late fourth and third century B.C.

The life-size terracotta head of a man on Pl. 14, although mould-made too, rises above the level of type-bound mass-production.

Strikingly individual touches added by the artist to the basic moulded shape before firing give a true portrait character to the head: a few deft lines engraved on the forehead and under the deep-set, searching eyes and the furrows running down from the nostrils to the corners of the disdainful mouth lend an expression of disillusion-ment and resignation to this arresting face; and a big wart on the upper lip adds an unflatteringly naturalistic touch. The only con-cession to contemporary Hellenistic fashion is in the treatment of the carefully modelled hair which forms a thick cap of loosely falling curls, in strong contrast with the surly realism of the strong, lean features. It points to a date in the third century B.C.

Such individualism is, however, only one trend in Etruscan portraiture of the Hellenistic period. Side by side with it we find an idealizing tendency which carries on the classical tradition of Greek models of the fourth century B.C. A characteristic example is pro-vided by the reclining female effigy on the lid of a large architec-turally treated terracotta sarcophagus from Chiusi, Pl. III, which, as we learn from an inscription incised on the base, belonged to Seianti Thanunia Tlesnasa, evidently a well-to-do Chiusine lady. Seianti Thanunia's vapid, full-cheeked face with its classically straight nose, triangular forehead, and evenly arched brows reflects a generalized ideal of beauty evolved in Greece during the fourth century; it is quite devoid of any originality or personal character. Yet, as a whole, the figure is modelled with great competence and decorative skill. Seianti Thanunia reclines on a mattress, her left elbow propped on a cushion, her left hand holding an open mirror, her right raised to draw back the mantle which covers her head. Her pose is typical of the later sarcophagus figures, most of whom half sit up and turn towards the spectator, instead of lying supine as the earlier figures do (Pl. 11). Extensive remains of colour—black, purple, brown, blueish-green, and yellow over a white slip—heighten the showy effect of the work. Great technical skill would have been required to form and fire such a large piece of sculpture; to facilitate the task the figure and the lid on which it rests were made in two separate parts, the join being almost completely concealed under the ample folds of the mantle. A date in the second century B.C. is suggested by Seianti Thanunia's hair-style, diadem, and ear-rings; and this is confirmed by the striking similarity which the sarcophagus bears to the sarcophagus of Larthia Seianti, also from Chiusi and

27

now in the Archaeological Museum of Florence, for the latter contained a Roman coin of 155–133 B.C.

According to the Italian dealer who sold it to a London dealer in 1908, the large bronze statuette of a girl on Pl. 15 was brought up from one of the imperial galleys at the bottom of Lake Nemi during diving operations in 1895. Other accounts, however, suggest that it was found near the site of the Temple of Diana on the shores of the lake; and this, as we shall see presently, is the more likely find-spot.

The girl, who wears a sleeveless chiton, cloak, and sandals, stands in a relaxed attitude, raising her slim arms and holding some light object in each of her long delicate hands, a fillet, perhaps, in the right and a bough in the left. She wears a torque round her neck and twisted bracelets on both wrists. Her hair rises in thick, unruly waves round the forehead and falls behind in three undulating tresses loosely tied at the nape. The deep-set eyes dominate the face, their moody expression reinforced by the pouting lines of her small sensuous mouth.

The figure is by far the largest and finest representative of a class of votive bronzes which have been found in large numbers in Etruscan and Latin sanctuaries and range in date from the third century B.C. to the first A.D. That our example comes fairly early in the series is indicated by various stylistic features. The loose-limbed, angular grace of the pose, the elongated, narrow-chested body, the gloomy cast of the features, the elegant disorder of the hair, and the harsh and arbitrary folds of the drapery—these are all characteristic traits of Etrusco-Latin works of the second century B.C. And this relatively early dating helps us to decide the question of the provenance, for a work of the second century B.C. is much less likely to have been found in an imperial galley than in the sanctuary of the *Dea Nemorensis*, which was already flourishing in the fifth century B.C.

Interesting from the technical point of view is the fact that the figure was cast in no less than nine separate pieces, which were subsequently hard-soldered together. A drip-mark on the inside of one of the pieces proves that the wax model needed for the casting was itself cast in a piece-mould taken from the preliminary model.

It may perhaps be illuminating to pause for a moment at this point and compare the girl from Nemi with the archaic girl on Pl. 8. The archaic figure seems completely absorbed in the action of offering. The gaze of her attentive, yet reposeful face is directed

straight in front of her, as if wholly intent on the task in hand. The entire figure is firmly enclosed within a contour-line which swells and sinks but is never broken; and the physical volume is thus concentrated in a compact, self-contained mass, from which neither gesture nor glance breaks out to make an appeal to the spectator. Created with the single aim of serving as a votive gift from a mortal to a divinity, the figure perfectly expresses its uniquely religious purpose in its artistic form.

The Hellenistic figure was also a votive object, but it is a much more complex creation. Sharply divergent lines give body, limbs, and drapery an independent life, which deliberately robs the figure of the formal unity achieved by the earlier work. The stance and the movement of the arms are designed to lead out into the surrounding space; and the moody eyes seek to communicate with some distant spectator. The purpose of the figure has become ambivalent. Though still meant as a gift to the gods, it is also intended to create an effect on human onlookers as a work of art. The simpler, self-sufficient faith of the archaic period had been modified in the intervening centuries; and the wistful expression of the face, the restless attitude, and the flickering surface-treatment of the figure reflect the infinitely more complex spiritual and intellectual situation of Hellenistic times.

By about 200 B.C. most Etruscan cities had finally succumbed to Rome and ceased to enjoy an independent political life. In art, however, local traditions continued to live on, and sculpture in central Italy underwent a revival as a result of the strong wave of Hellenistic influence which swept through the Mediterranean area in the wake of Rome's unifying conquests. Local sculptural traditions, though now imbued with Hellenistic spirit, survived especially in funerary art, where age-old customs, tenaciously adhered to, made for artistic continuity.

Once more we turn to the fertile inland city of Chiusi, whose carved stone ash-urns of the late archaic period have already claimed our attention. The terracotta urn on Pl. IV is an exceptionally well-preserved example of a series of painted urns made in Chiusi during the second century. The moulded front-panel of the chest shows a relief with an intricately interlocked group of five embattled warriors. This bloodthirsty scene recurs on a number of such urns and is typical of the gloomy subjects favoured for the decoration of later Etruscan funerary monuments. Two fluted

pilasters at the corners support an entablature, on the plain fascia of which is painted the inscription: Thana Ancarui Thelesa.

On the lid reclines the figure of a young man in a short-sleeved tunic with his left arm propped up on two pillows, his chest facing the spectator, and his head turned round towards his left shoulder. He wears a thick banqueter's wreath on his curly hair, and carelessly holds a libation bowl in his right hand. His knees are splayed out, the left foot tucked under the right leg, the right foot emerging from the folds of an ample cloak draped round the hips and left arm. The twisted disposition of body, limbs, and head is emphasized by the lines of the drapery which give a spiral torsion to the whole figure. The oblique upward and outward gaze of the young man passes the spectator by and seems to be fixed with an expression of transcendental yearning on some infinite goal. Both the figure and the relief are painted in vivid colours, applied over a white slip and including yellow, brown, red, mauve, blue, and black.

The closely-knit battle-scene on the chest is strongly reminiscent of the frieze from the great altar of Zeus at Pergamum in western Asia Minor, and illustrates how widely the influence of famous Hellenistic prototypes was diffused. Cinerary urns like the present example mark the climax of the Chiusine production in the second half of the second century, after which a general decline sets in.

We conclude our brief survey of Etruscan sculpture in the British Museum with an ash-urn of alabaster, the front of which is carved with a sacrificial procession in high relief, Pl. 16. The provenance of the urn, which was acquired in 1925 from the Forman Collection, is not known, but in view of its material and its close stylistic relationship with similar alabaster urns from Volterra in north-eastern Etruria, there can be little doubt that it, too, is a Volterran work. The lid of the urn, which would have supported the reclining figure of the deceased, is lost. Framed by mouldings above and below, the relief on the front panel represents a cavalcade of six horsemen, led by two musicians on foot and approaching a shrine. In front of the podium of the building a sacrificial attendant bends over a sheep. Raised on a high moulded base without any steps, the structure is probably a funerary monument. Its upper storey takes the form of a Corinthian temple with an elaborately panelled door and a pediment decorated with a snake-legged figure in relief (perhaps Summanus, an Etruscan divinity of the underworld). Possibly the

musicians and horsemen should be regarded as the vanguard of the kind of funeral processions we find on other Volterran urns of this type, which include the deceased in his wagon or in his chariot, but we cannot be certain of this. It may be that the cavalcade is merely visiting the shrine to perform a sacrifice. In any case the procession must be in some way connected with a magistrate, for the last horseman in the further row carries not only a palm-frond (as do all his companions), but also the *fasces*, an axe tied up in a bundle of rods, which was the emblem of magisterial authority. All the riders wear laurel wreaths, tunics, boots, and short cloaks twisted round the waist and slung over the shoulder; while the lyre- and double-pipe-players, who are also wreathed, wear a toga over their tunics. The figure holding the sheep is damaged, but was obviously dressed in the short kilt normally worn by sacrificial attendants. Remains of black, purple, and red paint add to the effectiveness of this solemn scene.

Compared with the Chiusine terracotta urn, the Volterran relief breathes an entirely different spirit. Instead of a consciously elegant composition of twisting, elongated figures fighting an imaginary battle, we meet here for the first time a straightforward representation of what may have been an actual ceremony. Dramatic and decorative effect has been replaced by a sober and slightly ponderous realism. In the simple, isocephalic alignment of these almost stunted figures, the repetition of a limited number of types, and the feeling of *pietas*, or religious duty, which informs the scene, the urn recalls certain provincial Roman funerary reliefs of republican times and foreshadows the infinitely grander historical and commemorative reliefs of the imperial period. We have, in fact, reached that moment in the first century B.C. when Etruscan sculpture ceases to exist as a separate art-form in central Italy, the point where it merges with the Hellenized art of Rome.

Although, as we have seen, Etruscan sculptors throughout the centuries drew much of their inspiration from foreign models, they never copied slavishly, but always succeeded in imparting an unmistakably local flavour to their works. The fresh immediacy of Etruscan sculpture, its arbitrary but expressive proportions, and its cheerful disregard for the logical development inherent in Greek sculpture give it an anti-classical quality which, though decried by art-lovers of earlier generations, has once more come into its own.

# Select Bibliography

G. Dennis. *The Cities and Cemeteries of Etruria*. 2 vols. 2nd edn. London, 1878.

P. J. Riis. *Tyrrhenika*. Copenhagen, 1941.

M. Pallottino–Skira. *Etruscan Painting*. Geneva, 1952.

M. Pallottino. *The Etruscans*. Penguin, 1955.

M. Pallottino–M. Hürlimann. *Art of the Etruscans*. Thames and Hudson, London, 1955.

E. Richardson. *The Etruscans*. The University of Chicago Press, 1964.

J. Heurgon. *Daily Life of the Etruscans*. Weidenfeld and Nicolson, London, 1964.

S. Haynes. *Etruscan Bronze Utensils*. The British Museum. London, 1965.

M. Moretti–G. Maetzke. *The Art of the Etruscans*. Thames and Hudson, London, 1970.

P. Ducati. *Storia dell'arte etrusca*. 2 vols. Florence, 1927.

G. Q. Giglioli. *L'arte etrusca*. Milan, 1935.

L. Banti. *Il mondo degli etruschi. Le grandi civiltà del passato*. Rome, 1960.

M. Pallottino. *Etruscologia*. 6th edn. Milan, 1968.

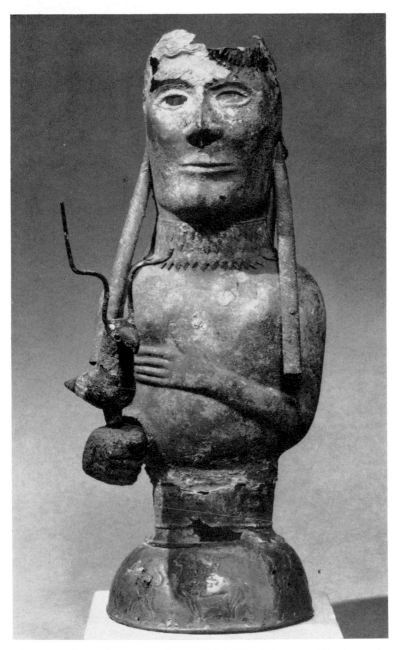

PLATE I. Bust of a woman. From Vulci. Height: 34 cm. (Bronze 434)

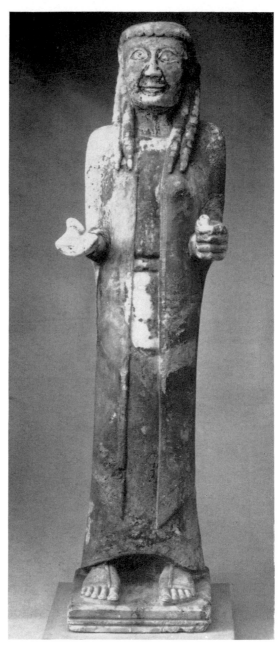

PLATE 2. Statuette of a woman. From Vulci.
Height: 88 cm. (Gypsum D 1)

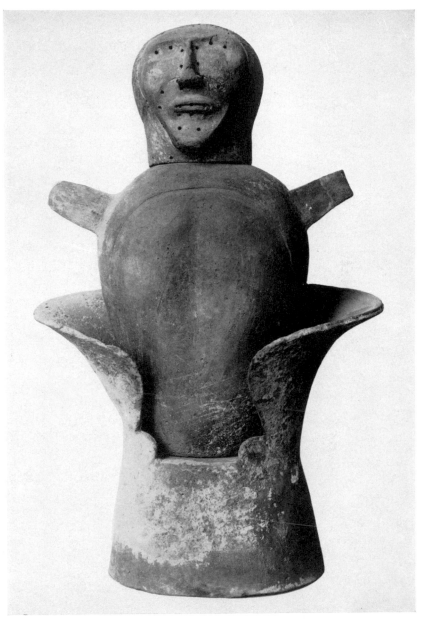

PLATE 3. Cinerary urn. From Chiusi. Total height: 58·3 cm.
(Terracotta H 245)

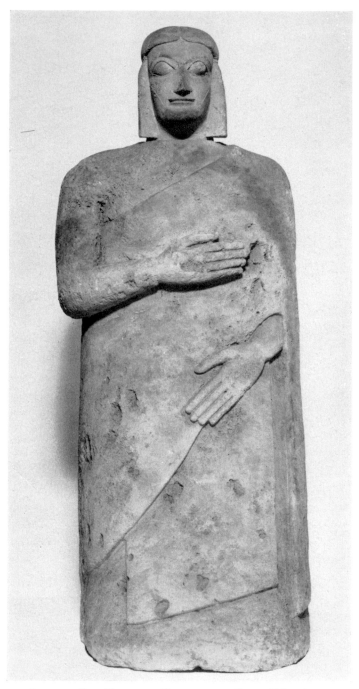

PLATE 4. Standing man. Cinerary urn. From Chianciano.
Height: 136 cm. (Limestone D 8)

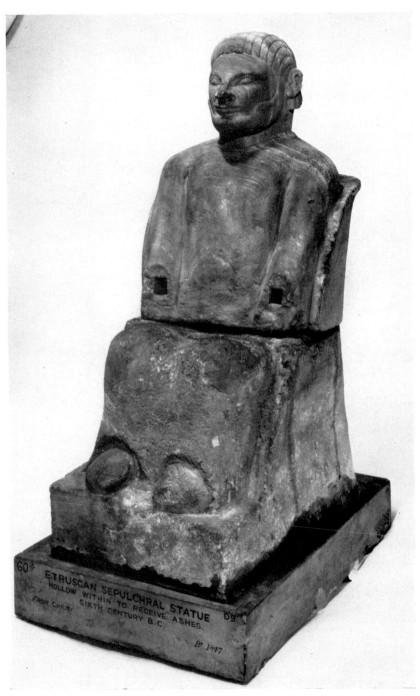

PLATE 5. Seated man. Cinerary urn. From Chiusi. Height: 138 cm.
(Limestone D 9)

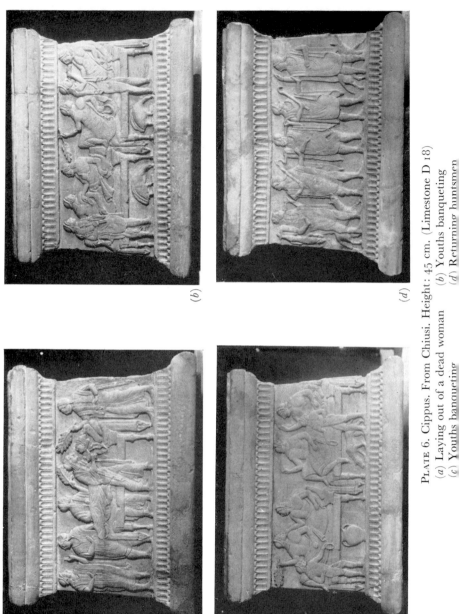

(b)

(d)

(a)

(c)

PLATE 6. Cippus. From Chiusi. Height: 45 cm. (Limestone D 18)
(a) Laying out of a dead woman          (b) Youths banqueting
(c) Youths banqueting                   (d) Returning huntsmen

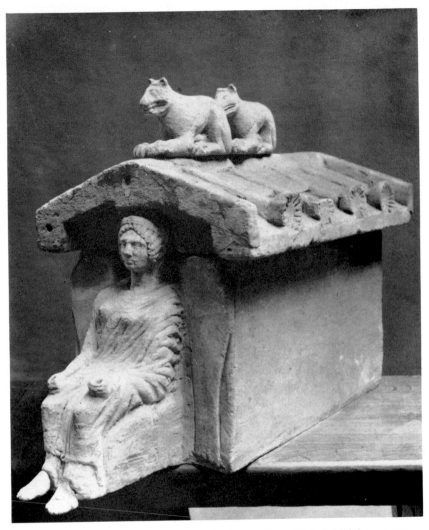

PLATE 7. Cinerary urn in the form of a house. From Chiusi. Height: 55 cm. (Limestone D 19)

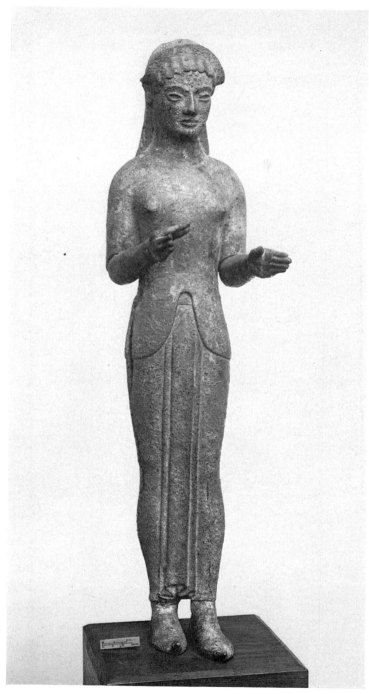

PLATE 8. Statuette of a girl. From the neighbourhood of Naples.
Height: 61 cm. (Bronze 447)

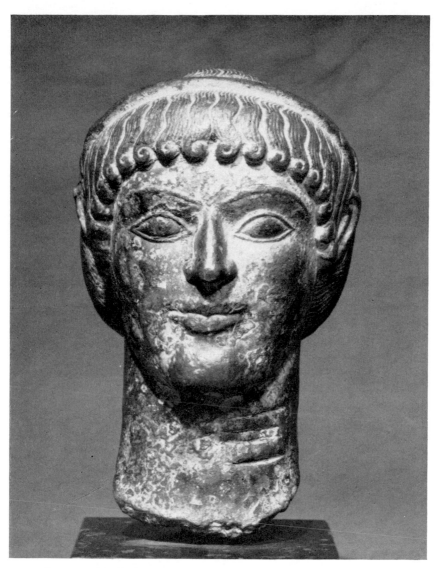

PLATE 9. Head of a youth. Provenance unknown. Height: 15·2 cm.
(Bronze 3212)

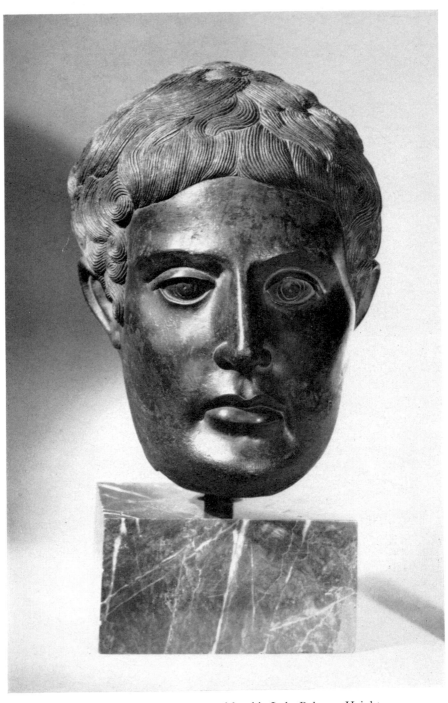

PLATE 10. Head of a youth. From an island in Lake Bolsena. Height: 25 cm.
(Bronze 1692)

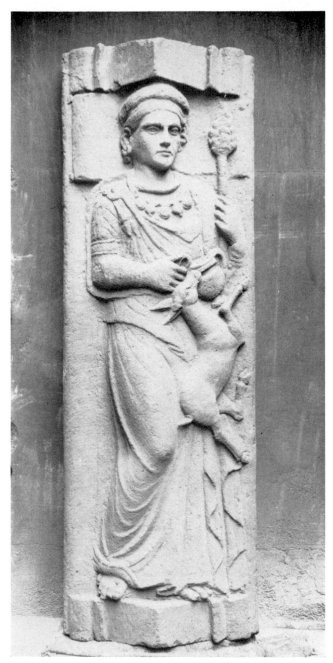

PLATE 11. Lid of a sarcophagus. From Tarquinia.
Length: 221 cm. (Nenfro D 22)

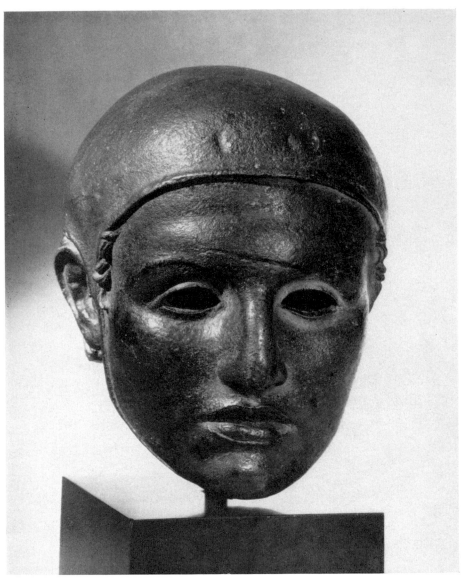

PLATE 12. Head of an athlete. Provenance unknown. Height: 20·3 cm.
(Bronze 1614)

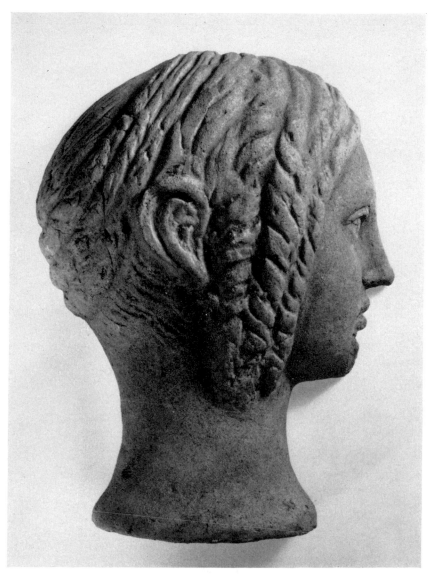

PLATE 13. Half-head of a girl. Provenance unknown. Height: 27·8 cm.
(Terracotta 1954. 9–14 1)

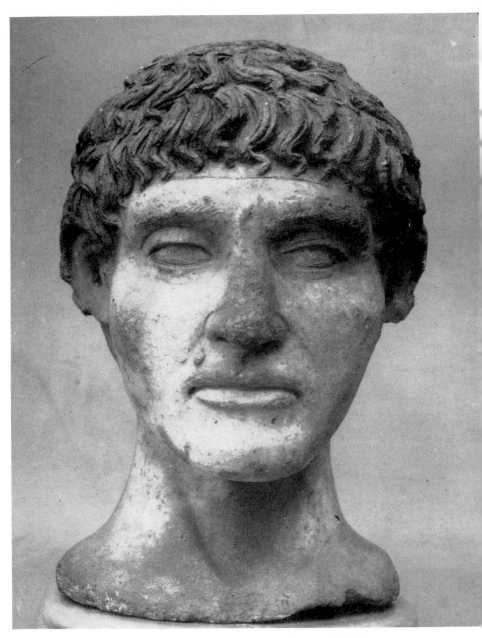

PLATE 14. Head of a man. Provenance unknown. Height: 30·4 cm.
(Terracotta 1956. 6–28 1)

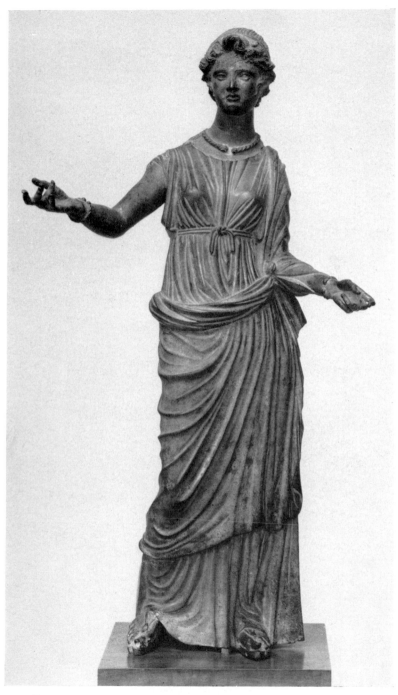

PLATE 15. Statuette of a girl. From Lake Nemi. Height: 97 cm.
(Bronze 1920. 6–12 1)

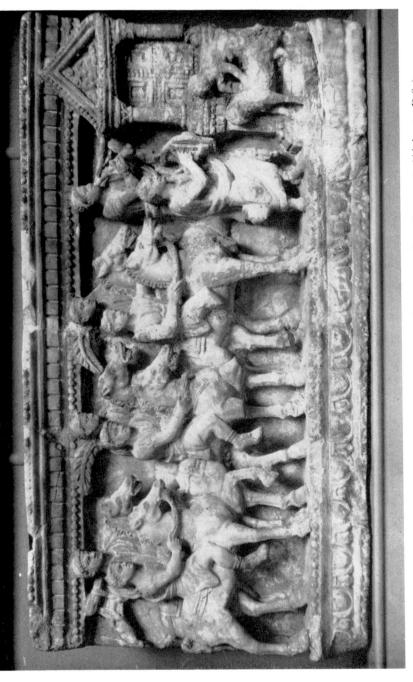

PLATE 16. Cinerary urn. Probably from Volterra. Height: 41 cm. Length: 73 cm. (Alabaster D 69)